W9-BIZ-002

Christmas
98
Kathi + Dave

Shakespeare Cats

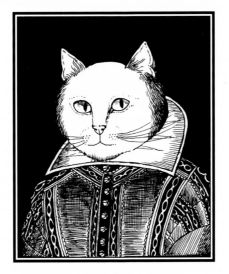

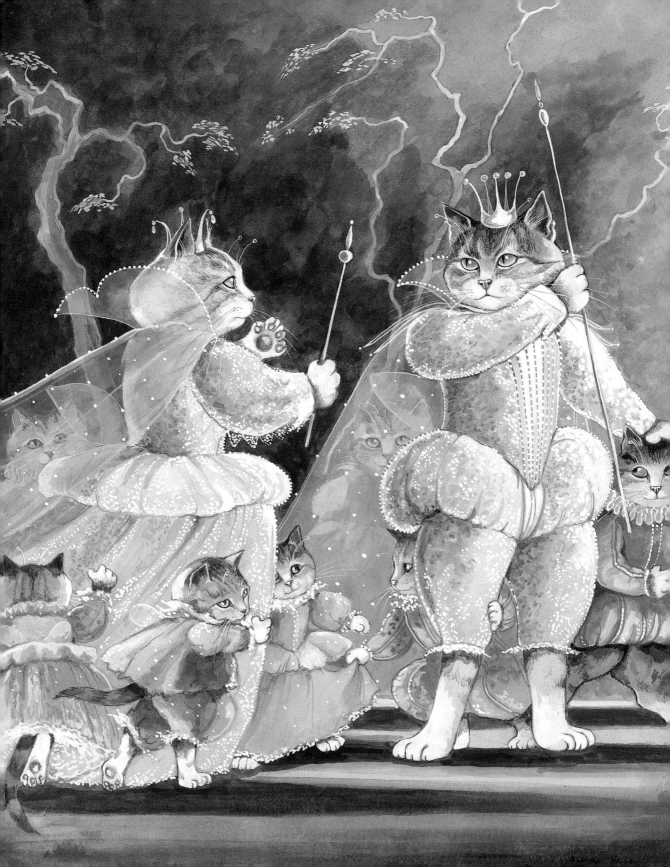

Shakespeare Cats

Susan Herbert

A BULFINCH PRESS BOOK
LITTLE, BROWN AND COMPANY
BOSTON • NEW YORK • TORONTO • LONDON

(FRONTISPIECE)
A Midsummer Night's Dream
ACT II SCENE I
Titania and Oberon *Ill met by moonlight, proud Titania.*

(OPPOSITE)
Macbeth
ACT I SCENE III
The three witches *All hail, Macbeth!*

First North American Edition
ISBN 0-8212-2281-3

Library of Congress Catalog Card Number 95-81808

Bulfinch Press is an imprint and trademark of
Little, Brown and Company (Inc.)
Published simultaneously in Canada by
Little, Brown & Company (Canada) Limited

PRINTED IN SINGAPORE

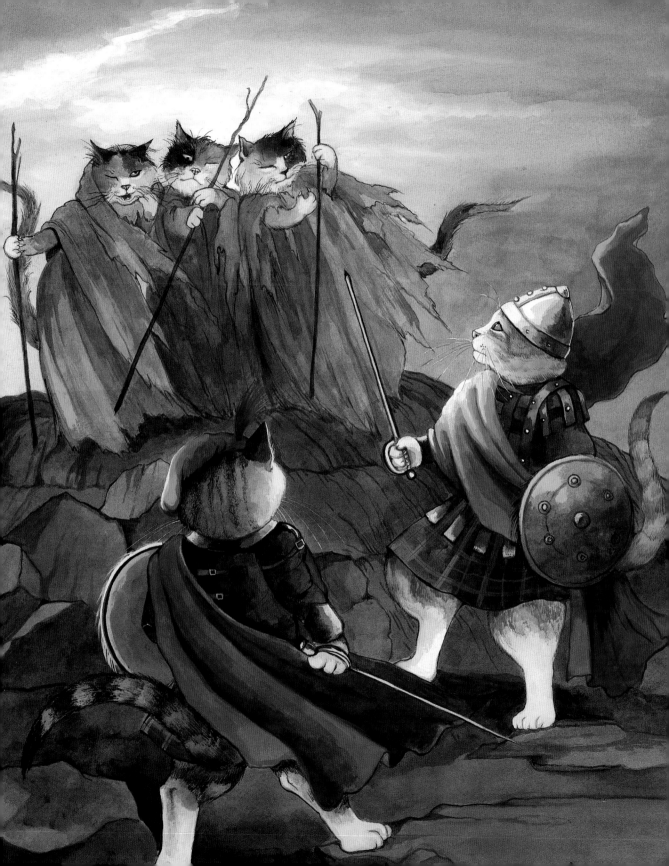

A Midsummer Night's Dream
ACT III SCENE II

As a result of Puck's mischievousness, Lysander and Demetrius, who were both in love with Hermia,
now find that they are both in love with Helena. Hermia is understandably put out.

I pray you, though you mock me, gentlemen,
Let her not hurt me. I was never curst;
I have no gift at all in shrewishness;
I am a right maid for my cowardice;
Let her not strike me. You perhaps may think,
Because she is something lower than myself,
That I can match her.

Puck

6

A Midsummer Night's Dream
ACT IV SCENE I

Titania, having had her eyes anointed with Oberon's love potion, falls in love with Bottom, the weaver, whose head has been converted into that of an ass by the playful Puck.

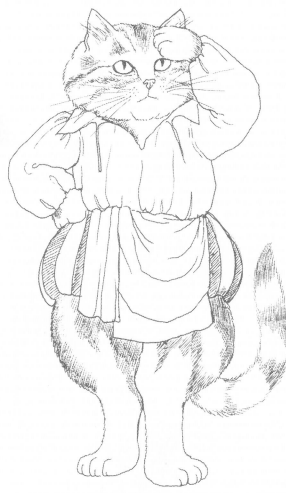

Bottom

*Come, sit thee down upon this
 flow'ry bed,
While I thy amiable cheeks do coy,
And stick musk-roses in thy sleek
 smooth head,
And kiss thy fair large ears, my
 gentle joy.*

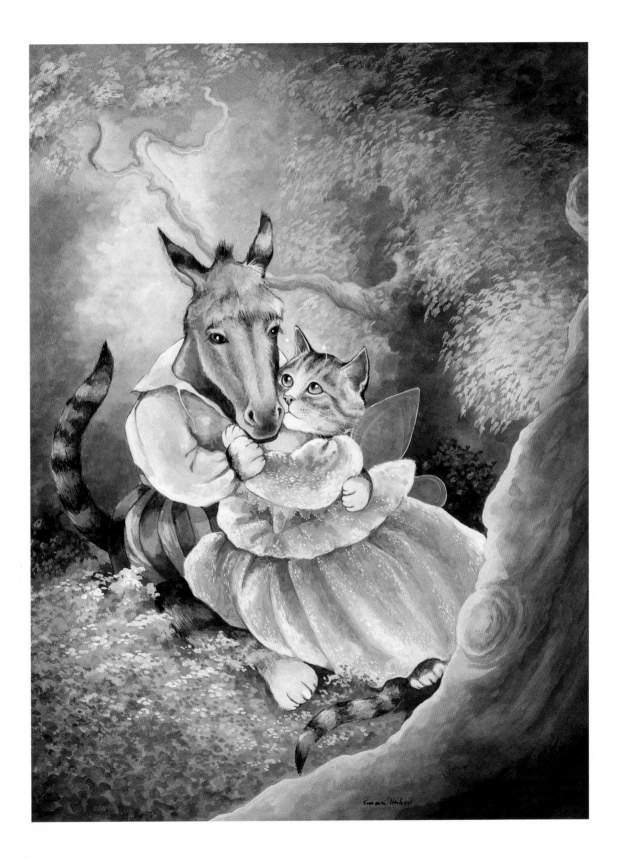

Susan Herbert

Romeo and Juliet

ACT II SCENE II

Romeo delays his departure from Juliet's balcony after their mutual declaration of love at first sight.

The Nurse

Good night, good night! Parting is such sweet sorrow
That I shall say good night till it be morrow.

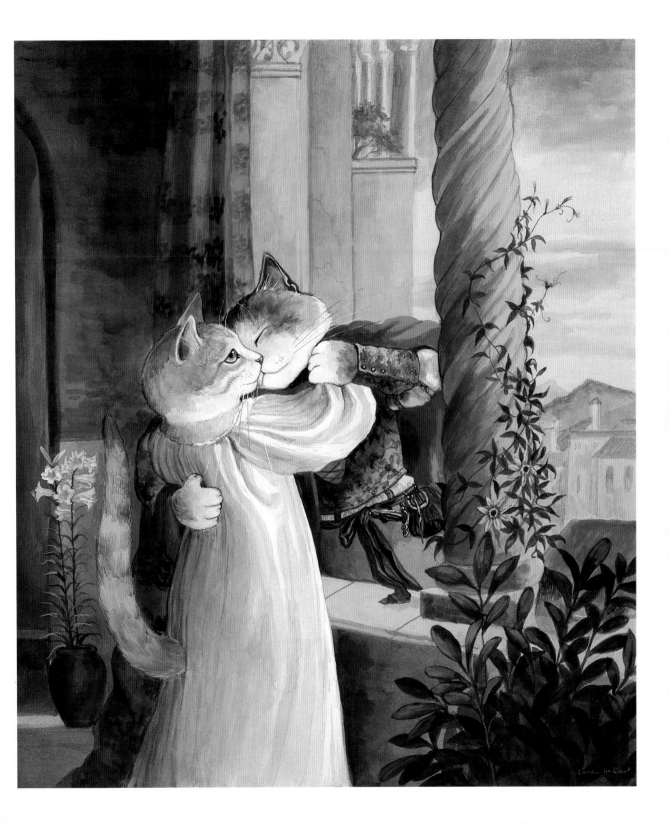

Romeo and Juliet

ACT V SCENE III

Having taken Friar Lawrence's potion to make her appear to be dead, Juliet is placed in the family vault. Unfortunately, Romeo thinks she is really dead and takes poison. When Juliet wakes and discovers his body, she stabs herself. Devastated by the loss of their children, the Montagues and Capulets bury their enmity.

Friar Lawrence

A glooming peace this morning with it brings;
The sun for sorrow will not show his head.
Go hence, to have more talk of these sad things;
Some shall be pardon'd and some punished;
For never was a story of more woe
Than this of Juliet and her Romeo.

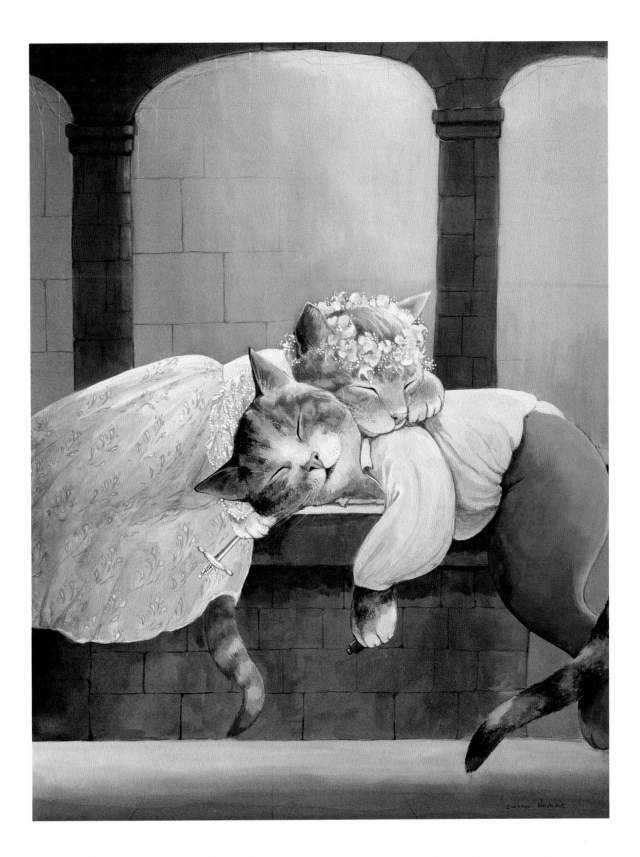

Henry IV Part II

ACT IV SCENE V

Prince Hal, believing his father to be dead, crowns himself somewhat prematurely.

*My due from thee is this imperial
 crown,
Which, as immediate from thy place
 and blood,
Derives itself to me.*

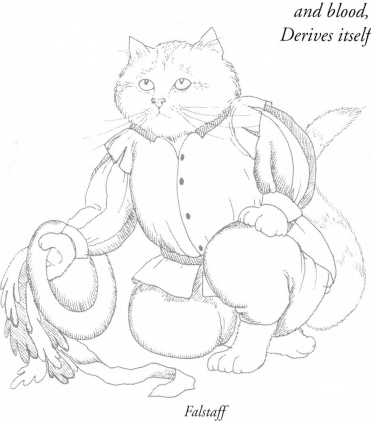

Falstaff

Henry V

ACT III SCENE I

Henry encourages his troops before the gates of Harfleur, which shortly afterwards surrenders to the English army.

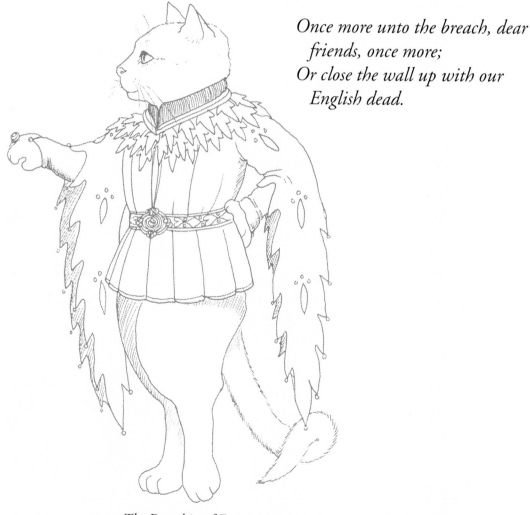

Once more unto the breach, dear friends, once more;
Or close the wall up with our English dead.

The Dauphin of France

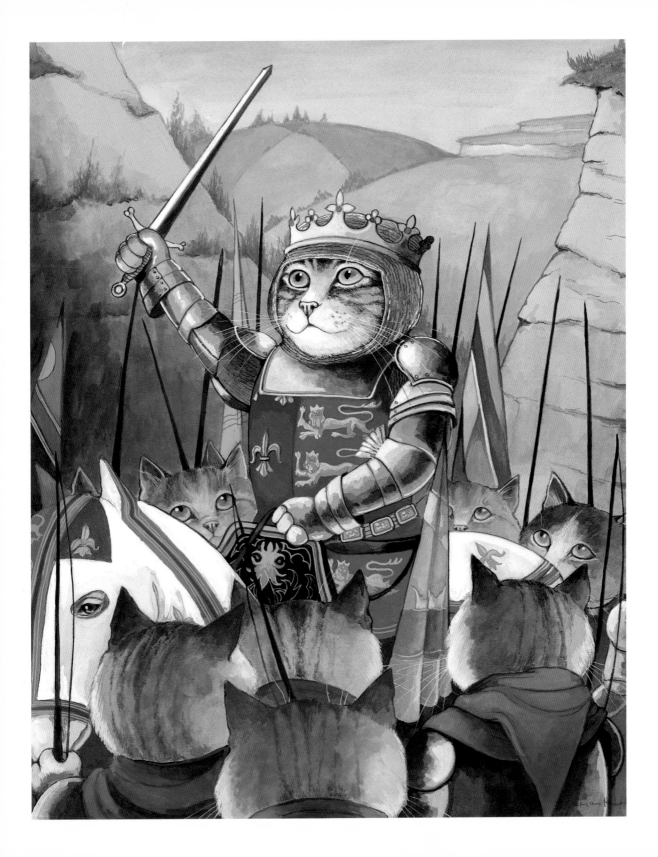

Henry V
ACT V SCENE II

After achieving a spectacular victory at Agincourt, Henry V
woos Princess Katherine, daughter of the French king.

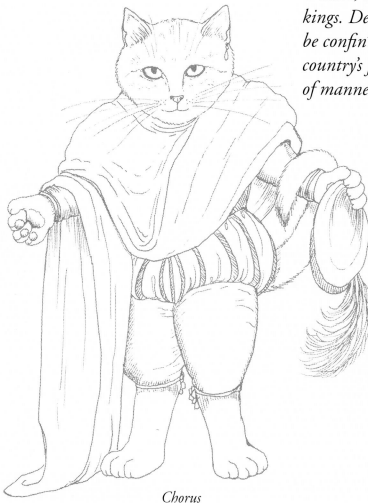

O Kate, nice customs curtsy to great kings. Dear Kate, you and I cannot be confin'd within the weak list of a country's fashion; we are the makers of manners, Kate.

Chorus

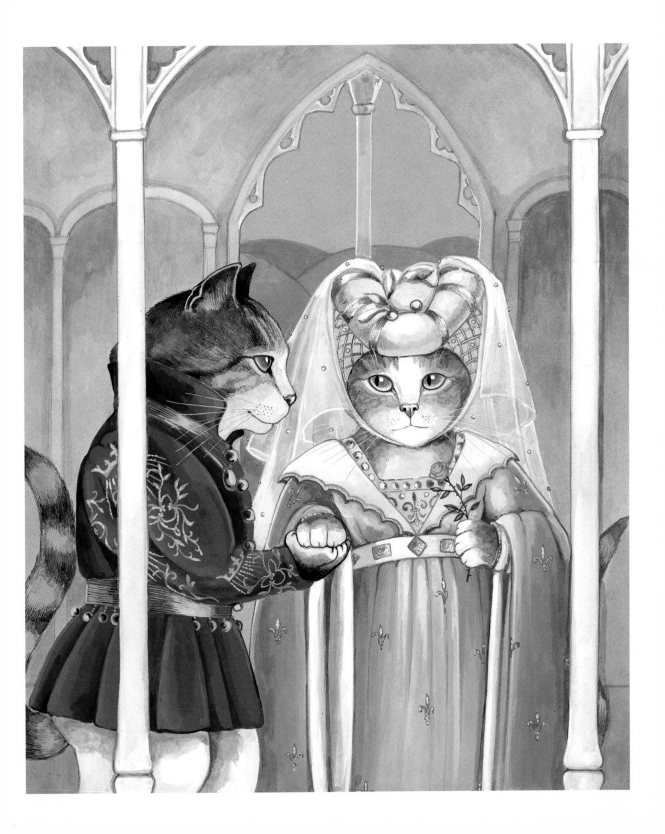

The Taming of the Shrew
ACT III SCENE II

Having married Katherina, Petruchio removes her from the scene
without partaking of the wedding breakfast.

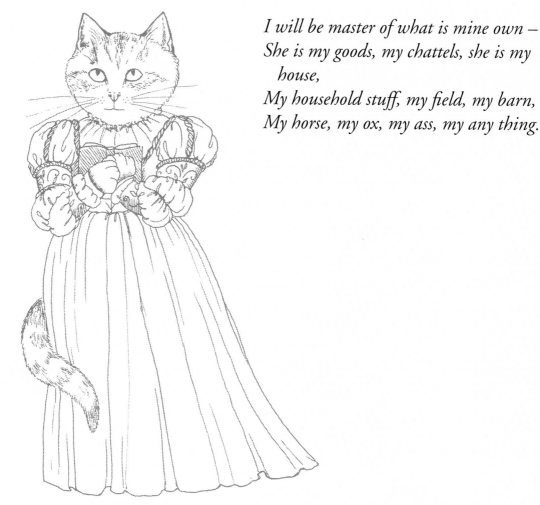

I will be master of what is mine own —
She is my goods, my chattels, she is my
 house,
My household stuff, my field, my barn,
My horse, my ox, my ass, my any thing.

Bianca

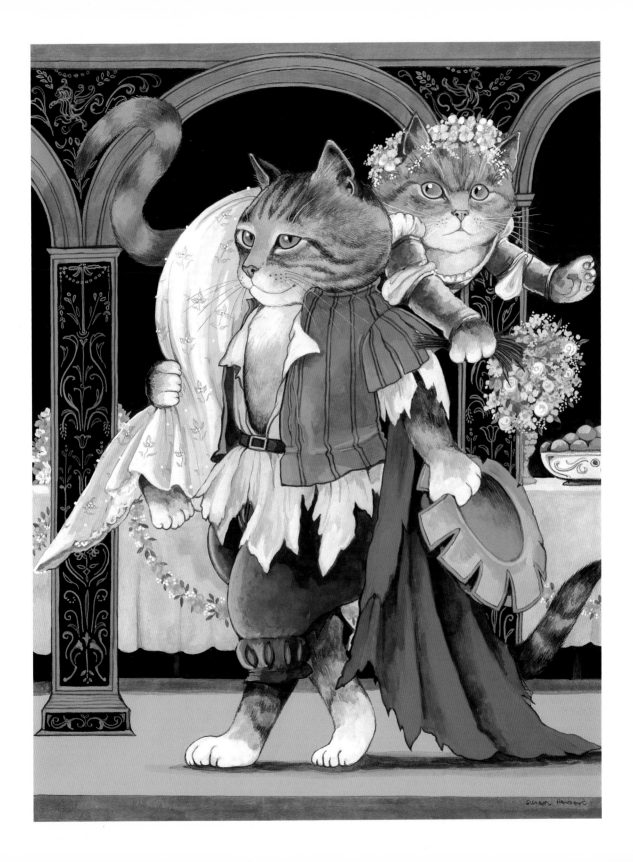

The Merchant of Venice
ACT II SCENE VII

The lady Portia's father left his will in a strange manner. Any suitor for his daughter's hand is required to choose from three caskets (gold, silver and lead). The winning casket contains Portia's likeness. The Prince of Morocco has chosen the golden casket, which contains this disappointing message.

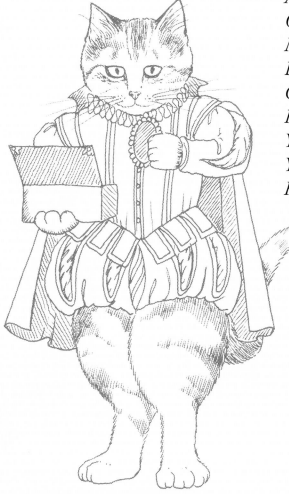

Bassanio

All that glisters is not gold,
Often have you heard that told;
Many a man his life hath sold
But my outside to behold.
Gilded tombs do worms infold.
Had you been as wise as bold,
Young in limbs, in judgment old,
Your answer had not been inscroll'd.
Fare you well, your suit is cold.

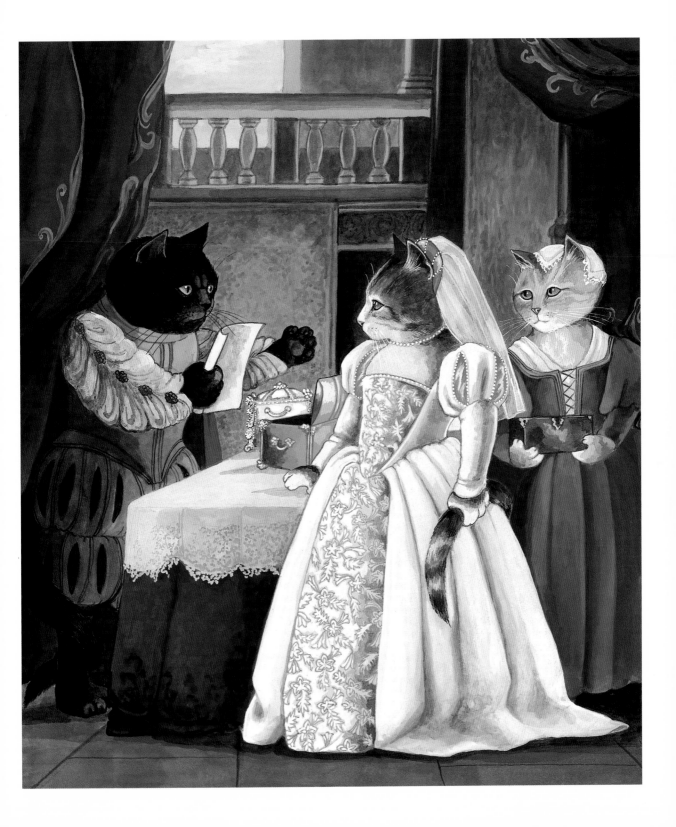

The Merchant of Venice
ACT IV SCENE I

Portia, disguised as a learned doctor, attempts to persuade Shylock not to insist on the letter
of his bond, which entitles him to cut a pound of flesh from the merchant Antonio.

The quality of mercy is not strain'd;
It droppeth as the gentle rain from heaven
Upon the place beneath. It is twice blest:
It blesseth him that gives and him that takes.

Lorenzo and Jessica

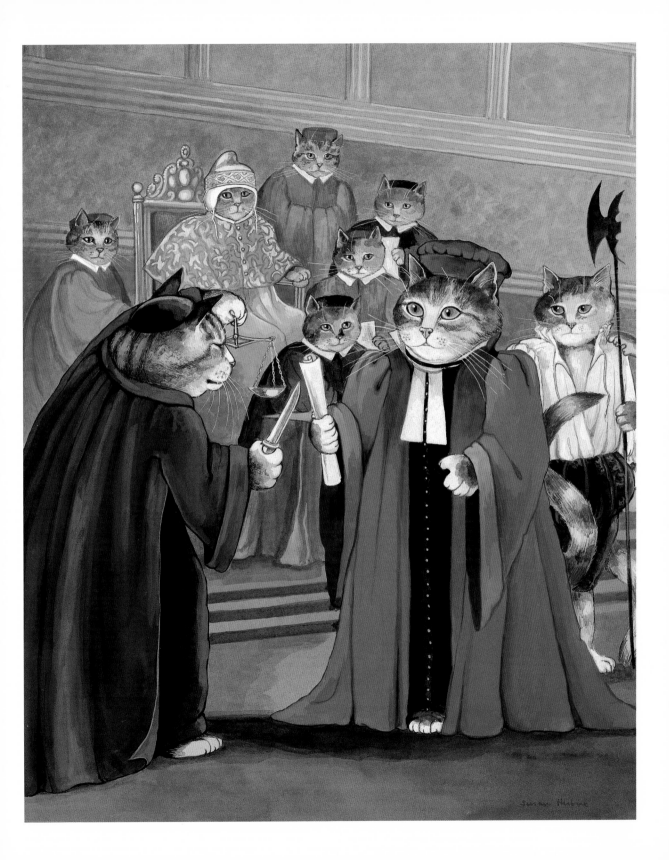

Richard II
ACT I SCENE I

Richard greets his uncle and his cousin Henry Bolingbroke, who have been summoned
to give their account of Bolingbroke's dispute with Thomas Mowbray.

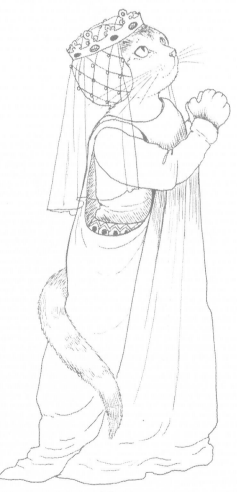

The Queen

Old John of Gaunt, time-honoured Lancaster,
Hast thou, according to thy oath and band,
Brought hither Henry Hereford, thy bold son,
Here to make good the boist'rous late appeal
Which then our leisure would not let us hear,
Against the Duke of Norfolk, Thomas Mowbray?

26

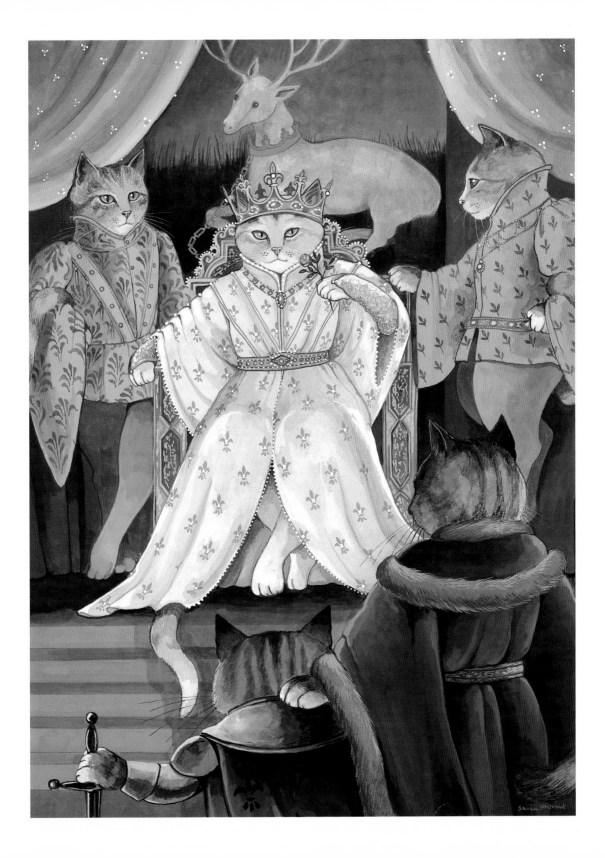

The Merry Wives of Windsor

ACT III SCENE V

Falstaff relates to Ford (disguised as Master Brook) how he was forced to hide in
a laundry basket to escape detection while illicitly wooing Mistress Ford.

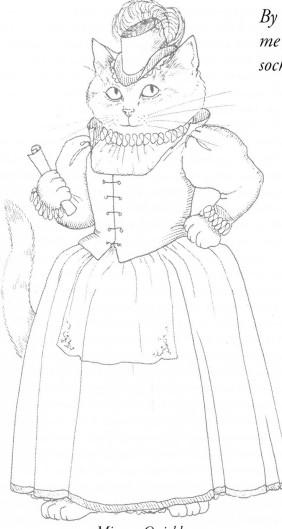

*By the Lord, a buck-basket! Ramm'd
me in with foul shirts and smocks,
socks, foul stockings!*

Mistress Quickly

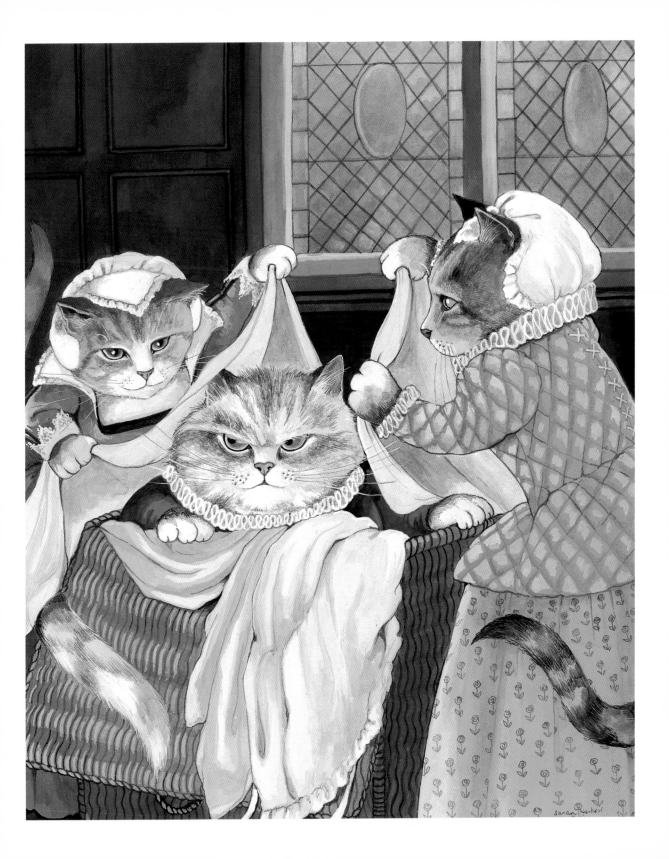

Richard III

ACT I SCENE I

Richard, Duke of Gloucester, conceals the fact that he is plotting to remove
all obstacles that stand between himself and the crown of England.

Now is the winter of our discontent
Made glorious summer by this sun of York;
And all the clouds that lour'd upon our house
In the deep bosom of the ocean buried.

Lady Anne

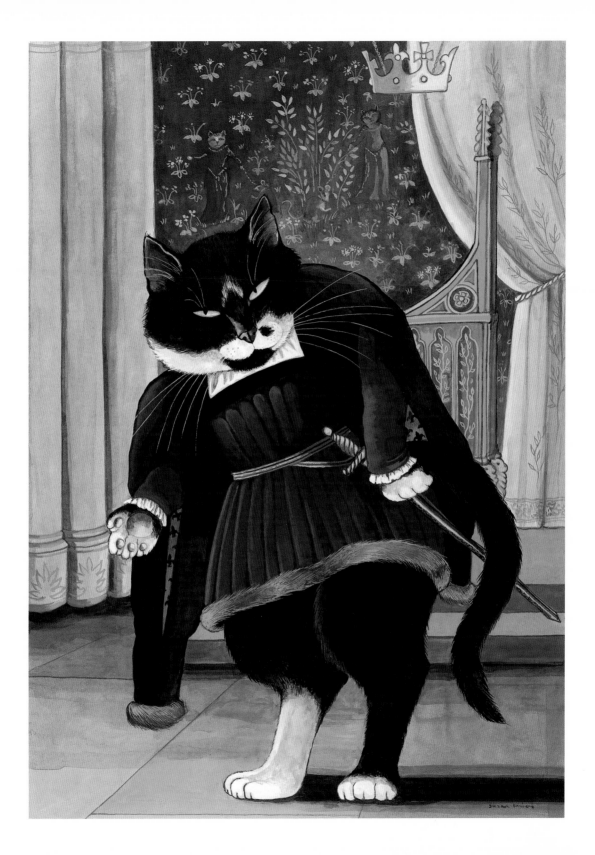

Richard III
ACT IV SCENE III

Under instructions from Sir James Tyrell, the two assassins Dighton and Forrest
smother the young King Edward V and his younger brother, Richard, Duke of York.
By this foul deed the throne is cleared for Richard III.

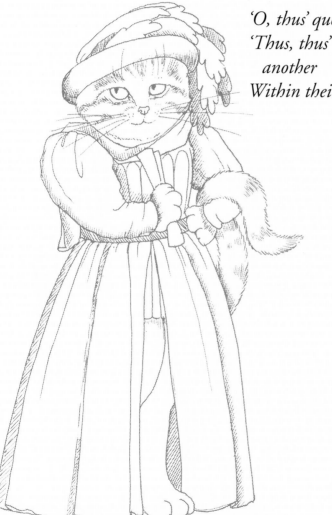

'O, thus' quoth Dighton 'lay the gentle babes' -
'Thus, thus' quoth Forrest 'girdling one
 another
Within their alabaster innocent arms.'

Duke of Buckingham

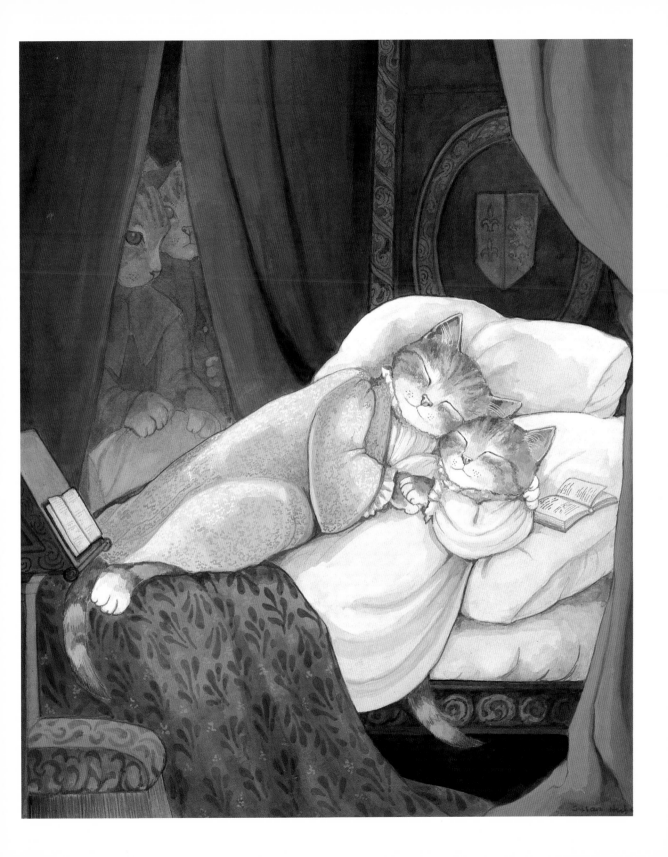

As You Like It

ACT II SCENE VII

The cynical Jaques, a companion of the banished Duke, entertains the rest of
the party in the Forest of Arden with his discourse on the seven ages of man.

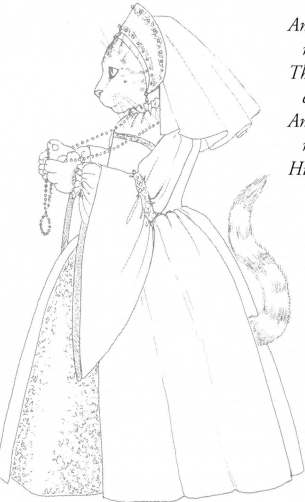

Rosalind

All the world's a stage,
And all the men and women
merely players;
They have their exits and their
entrances;
And one man in his time plays
many parts,
His acts being seven ages.

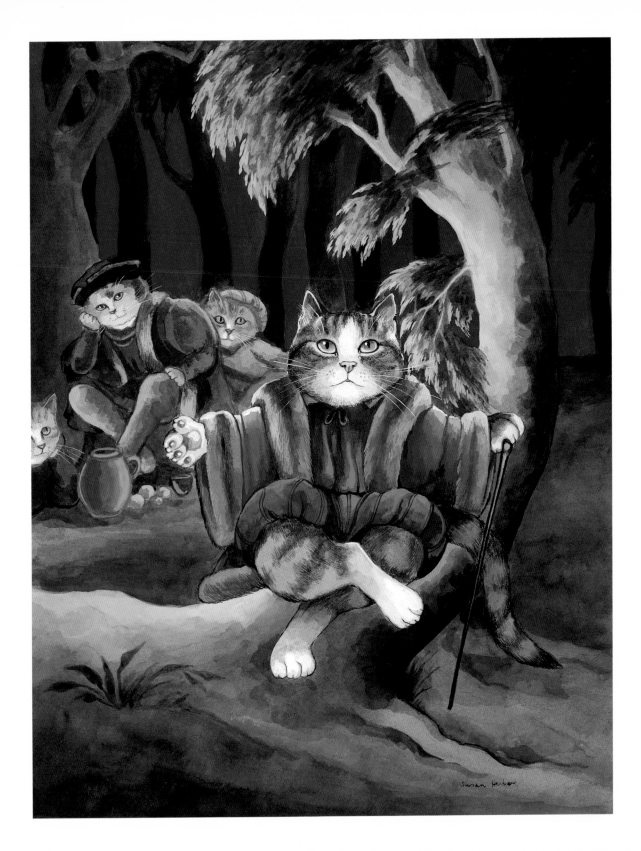

Julius Caesar
ACT III SCENE II

After the assassination of Caesar, his friend Mark Antony addresses the mob with wit and irony, and gradually turns their mood from hostility toward Caesar into a desire for revenge on his murderers.

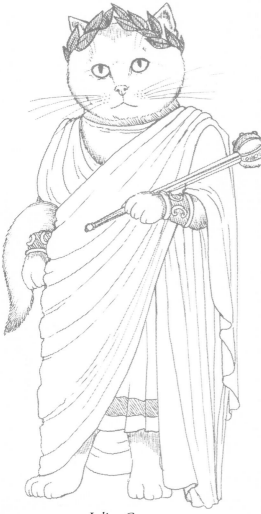

*Friends, Romans, countrymen, lend
 me your ears;
I come to bury Caesar, not to praise
 him.
The evil that men do lives after them;
The good is oft interred with their
 bones;
So let it be with Caesar.*

Julius Caesar

36

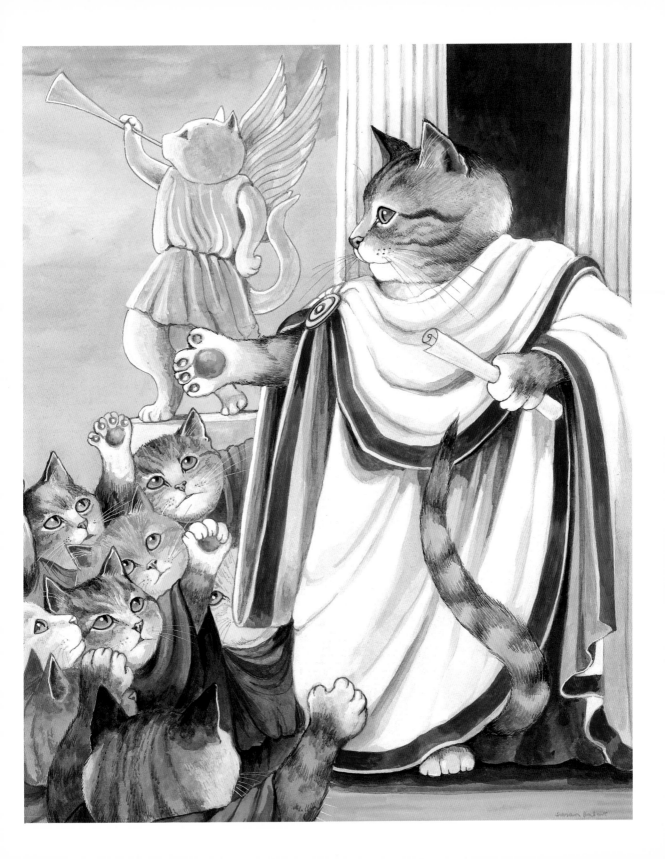

Twelfth Night

ACT III SCENE IV

Malvolio, in the mistaken belief that the Countess Olivia is in love with him, appears before her smiling smugly and sporting yellow stockings with crossed garters, while the other members of the household look on from their hiding places.

Some are born great, some achieve greatness, and some have greatness thrust upon 'em.

Feste

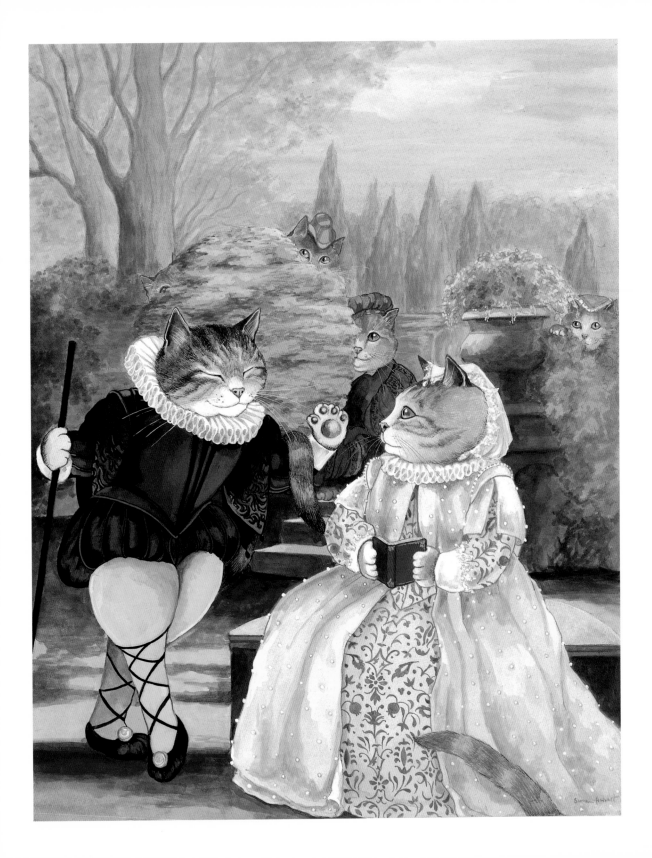

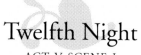

Twelfth Night

ACT V SCENE I

The twins Viola and Sebastian, each believing the other to have drowned
in a shipwreck, greet one another rapturously.

Were you a woman, as the rest goes even,
I should my tears let fall upon your cheek,
And say 'Thrice welcome, drowned Viola!'

Aguecheek

Much Ado About Nothing

ACT II SCENE I

Beatrice, pretending not to recognize Benedick, delivers a very unflattering
description of him while they dance at Leonato's ball.

Why, he is the Prince's jester, a very dull fool; only his gift is in devising impossible slanders; none but libertines delight in him, and the commendation is not in his wit but in his villainy; for he both pleases men and angers them, and then they laugh at him and beat him.

Hero

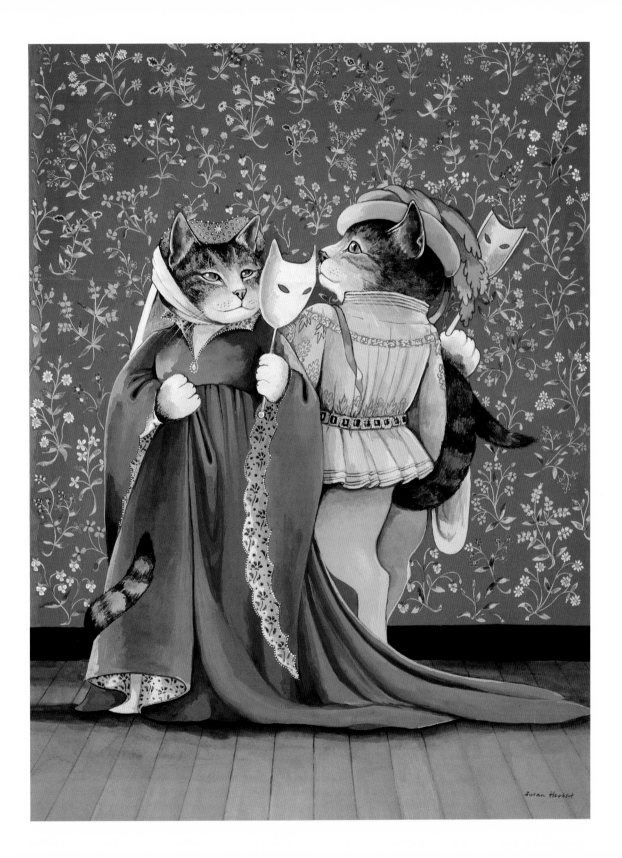

Macbeth
ACT II SCENE II

After murdering Duncan, Macbeth has distractedly brought away the daggers with him. Appalled at what he has done, he cannot bring himself to put the daggers back; but Lady Macbeth, made of sterner stuff, takes over.

Infirm of purpose!
Give me the daggers. The sleeping
and the dead
Are but as pictures; 'tis the eye of
childhood
That fears a painted devil.

Macduff

44

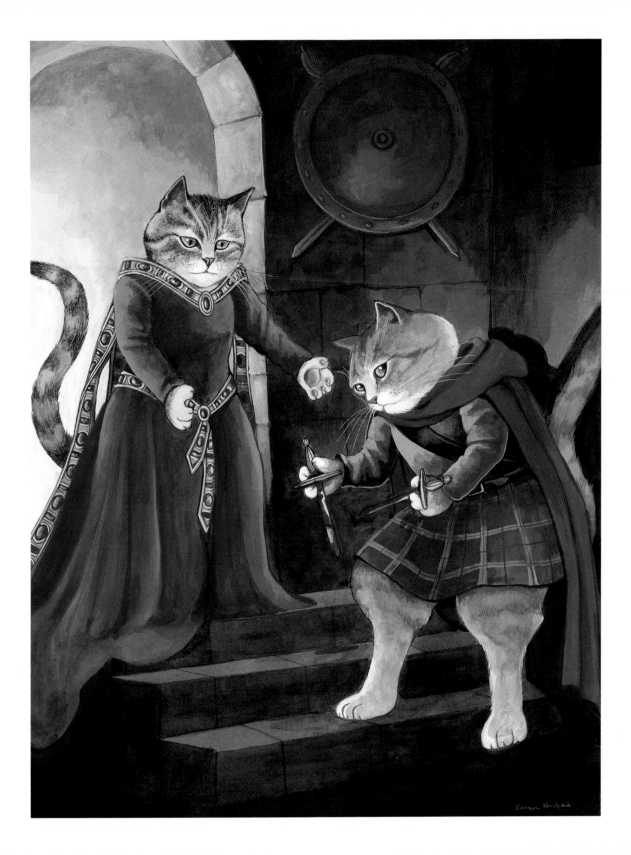

Macbeth
ACT V SCENE V

Malcolm's soldiers, each holding a branch of a tree before him, approach
Macbeth's castle, thus fulfilling the witches' strange prophecy.

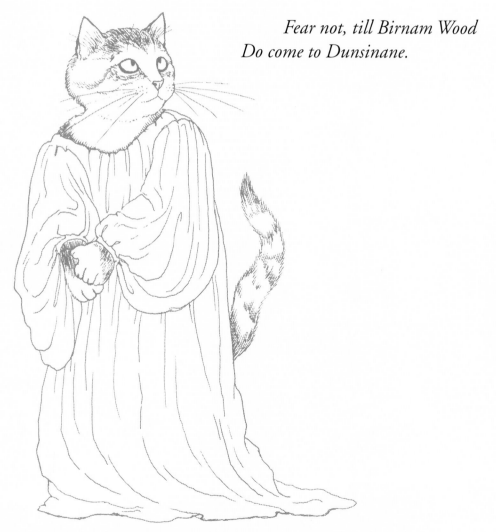

*Fear not, till Birnam Wood
Do come to Dunsinane.*

Lady Macbeth

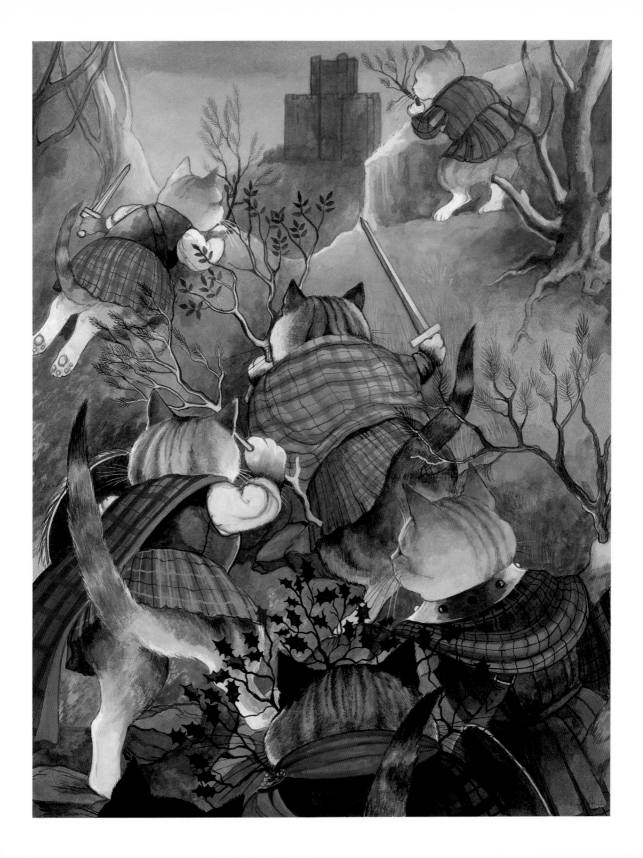

Hamlet

Gertrude describes the drowning of the mad Ophelia to her brother Laertes.

There is a willow grows aslant the
* brook*
That shows his hoar leaves in the glassy
* stream;*
There with fantastic garlands did she
* come*
Of crow-flowers, nettles, daisies and
* long purples*
That liberal shepherds give a grosser
* name,*
But our cold maids do dead men's
* fingers call them.*

Polonius

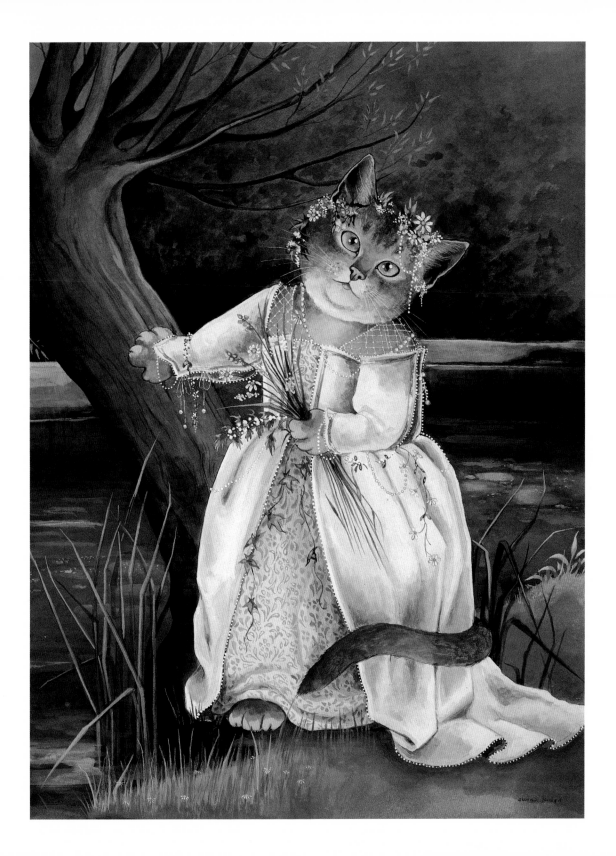

Hamlet
ACT V SCENE I

Returning from England, Hamlet and his companion Horatio encounter a gravedigger
who, unbeknownst to Hamlet, is actually preparing a grave for the drowned Ophelia.
While chatting, the gravedigger unearths the skull of Yorick, the late King's jester.

Alas, poor Yorick! I knew him,
Horatio: a fellow of infinite jest,
of most excellent fancy; he hath borne
me on his back a thousand times.

Ophelia

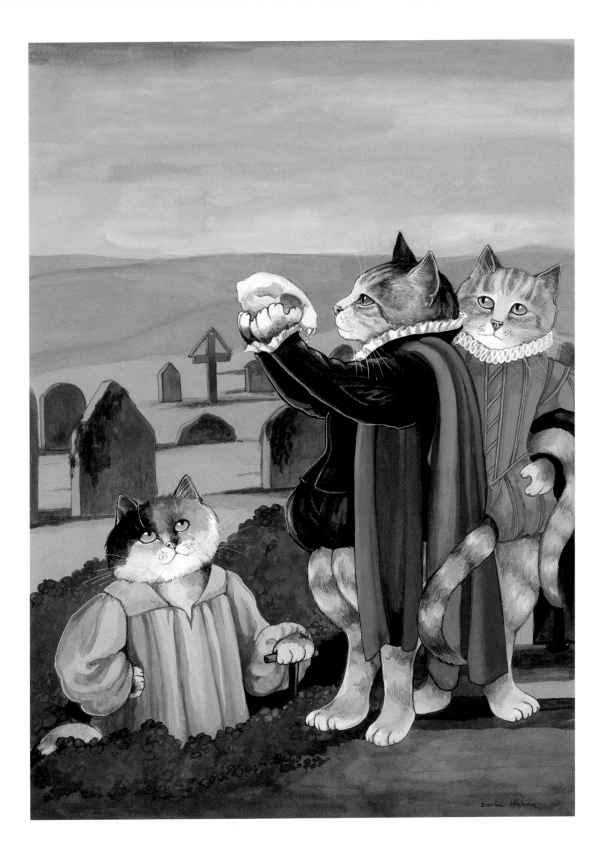

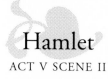

Hamlet

ACT V SCENE II

While Hamlet fights a duel to the death with Laertes, who is seeking revenge
for the deaths of his father and his sister, King Claudius is alarmed to see the Queen
about to drink from the goblet which he has carefully poisoned for Hamlet.

Part them; they are incens'd

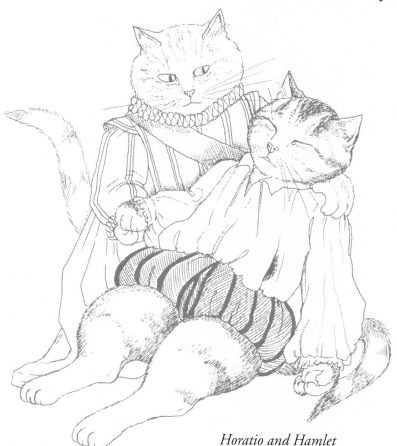

Horatio and Hamlet

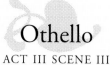

Othello

ACT III SCENE III

Iago begins his campaign to convince Othello that the innocent
Desdemona is being unfaithful to him with Cassio.

O, beware, my lord, of jealousy;
It is the green-ey'd monster which doth mock
The meat it feeds on. That cuckold lives in bliss
Who, certain of his fate, loves not his wronger;
But, O, what damned minutes tells he o'er
Who dotes, yet doubts, suspects, yet strongly loves.

Cassio

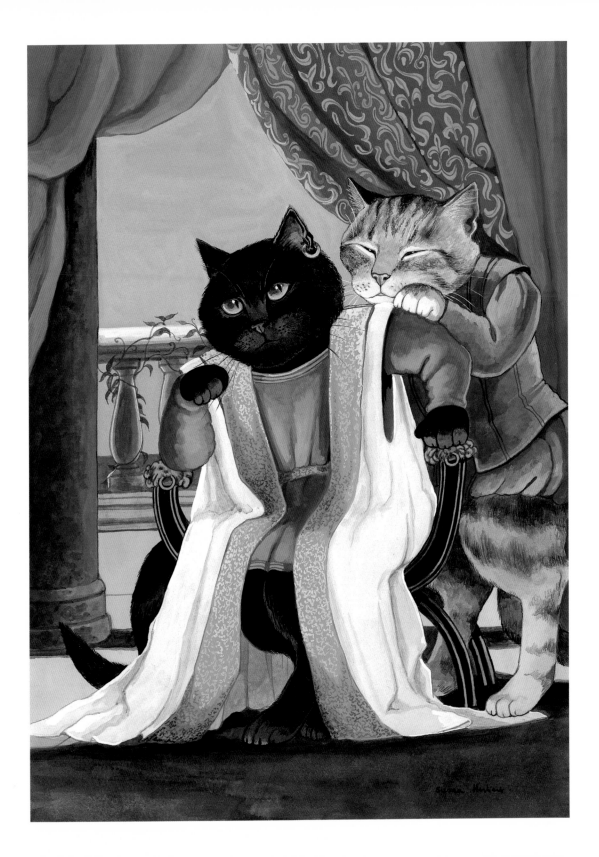

Othello

ACT V SCENE II

Desdemona protests her innocence and begs Othello to spare her life.

Kill me tomorrow; let me live tonight.

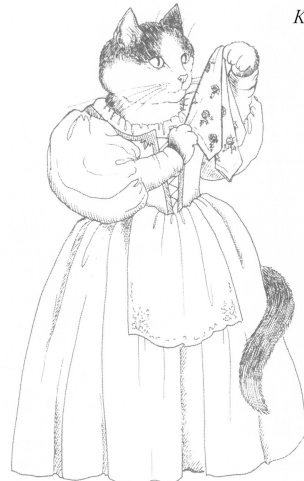

Emilia

Antony and Cleopatra

ACT II SCENE II

Enobarbus describes Queen Cleopatra to Agrippa and Maecenas.

Age cannot wither her, nor custom stale
Her infinite variety.

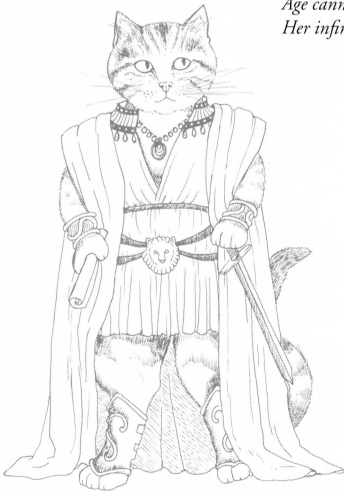

Antony

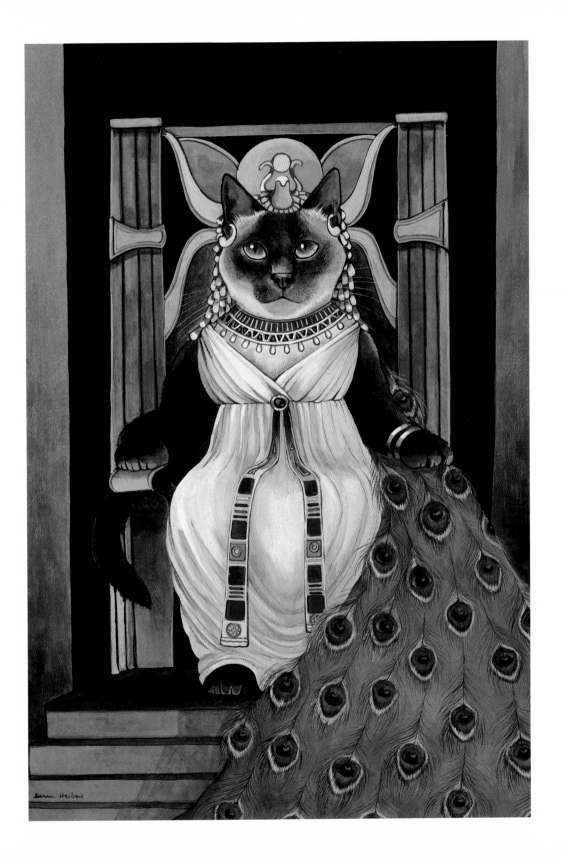

King Lear

ACT I SCENE I

Unlike her two evil sisters, Goneril and Regan, the honest Cordelia refuses
to flatter her father the King with a shower of empty compliments.

Unhappy that I am, I cannot heave
My heart into my mouth. I love your Majesty
According to my bond; nor more nor less.

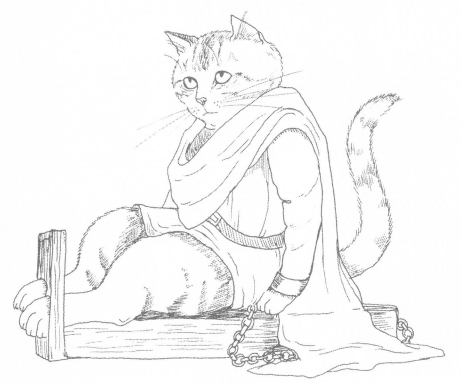

Duke of Kent

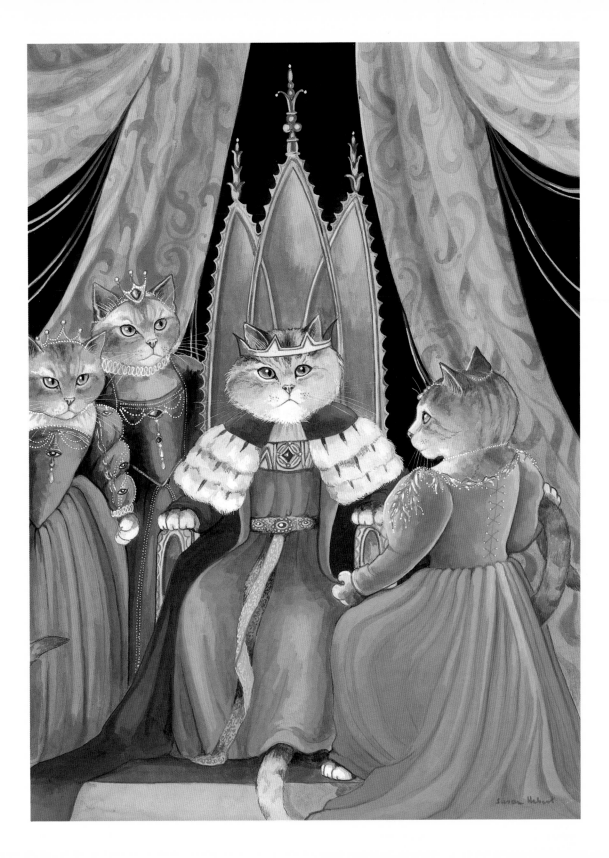

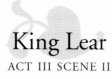

King Lear
ACT III SCENE II

Disillusioned by the churlish behaviour of his two selfish daughters, Regan and Goneril,
King Lear, accompanied by his faithful Fool, rages at the gathering storm.

Blow, winds, and crack your cheeks;
rage, blow.

Edgar

(OVERLEAF)
The Tempest
ACT I SCENE II
Prospero and Miranda after the storm

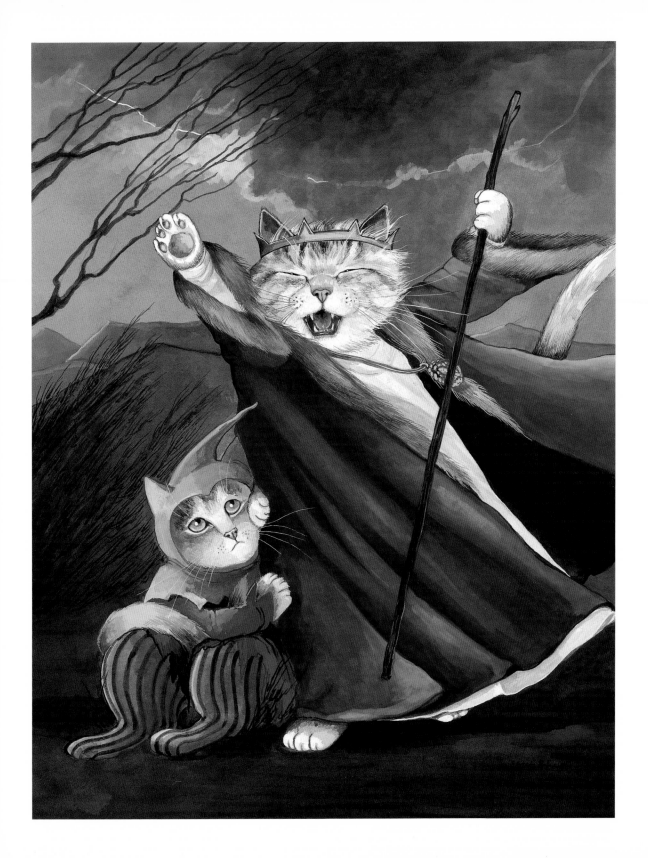